THE ART OF WILL BULLAS

a fool and his bunny ...

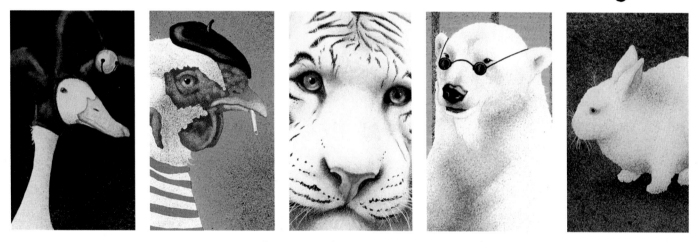

Introduction by Clint Eastwood

THE GREENWICH WORKSHOP, INC.

Possibly the earliest encounters I had with the art of Will Bullas were a meeting with a rhinoceros enjoying a glass of wine, and one with a few raccoons and some crazy pig who thought he was a raccoon—a rather unusual way of looking at the animal kingdom.

Upon closer examination of Will's paintings, it became evident that titles are an integral part of each piece of art. Could there be any other title for a rhinoceros drinking red wine than *wineoceros...?* And the pig was obviously trying to be *just one of the guys....*

In 1986 I learned that four-legged critters weren't the only subjects depicted in his paintings. The painting shown on this page was created during my campaign for the office of Mayor of Carmel-by-the-Sea. Proof that he also has an unusual way of looking at two-legged critters. *The human element...* chapter in this book offers additional examples. Will's flare for the dramatic is evident as he portrays himself in such paintings as *jesters do often prove prophets...* and *the mad monk....*

The other three sections feature the paintings for which he has become well known. Paintings such as *Zippo...the fire eater, the jailbirds..., goin' ape down at the monkey bars...* and *rhino in the rough...* (reminds me of some of my golfing buddies) are among the great examples of Will's particular brand of wit.

Over the years Will has used his talents to poke gentle fun at a variety of creatures in his universe. He has also used his art to bring fun into the lives of others through numerous donations to local charities. As matter of fact, this book will be used to raise money for a local youth center. And that will certainly help to "make my day"!

Clint Eastwood

PART I

braving the elements...

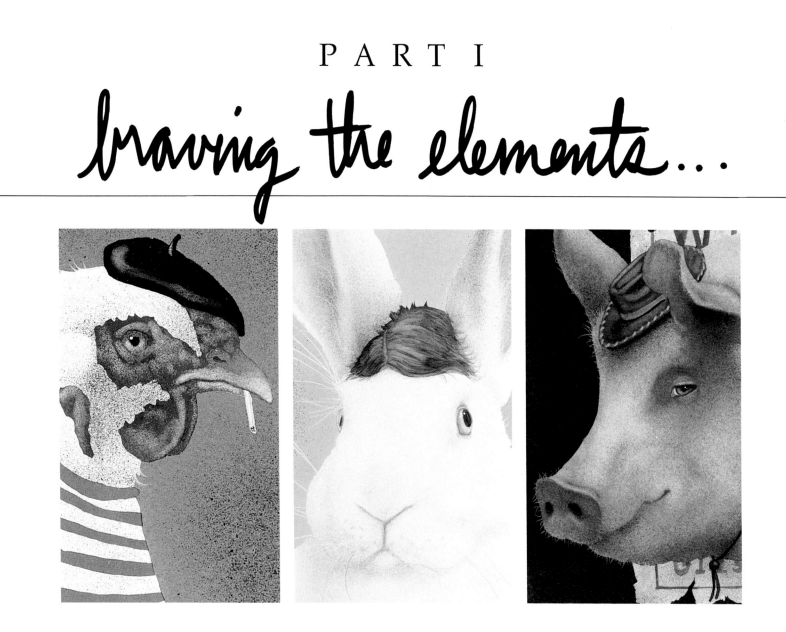

braving the elements...

Say hello to a few new friends, courtesy of Will Bullas. Slightly familiar? Perhaps. Slightly askew? Definitely. And why not? They're simply doing their best to get by in a world that's just a little larger than us.

Brandishing paper, palette, brush, a finely tuned wit, and a fondness for one-liners, Will jousts amicably with the not-so-animal kingdom. Perhaps the ducks and chicks are to blame. Or maybe the fault lies with the rabbits, who, in his boyhood, lived in the backyard. His brother-in-law's playfully untrainable golden lab might have been the culprit. Whoever (or whatever) is responsible, Will's life-long love affair with fine, furry, or feathered friends has provided him with a humorous way of coping with the pitfalls and pratfalls of existence.

Laboring upon the ponderous (or pondering on the laborious), it would be easy to ask, "Is it we humans who have animal characteristics, or do the animals have human ones?" Now add to the equation a pig in a pink tutu, a daredevil duck, and a rabbit with a rug, and ask that question again. Congratulations! You're one step closer to the mind of Will Bullas.

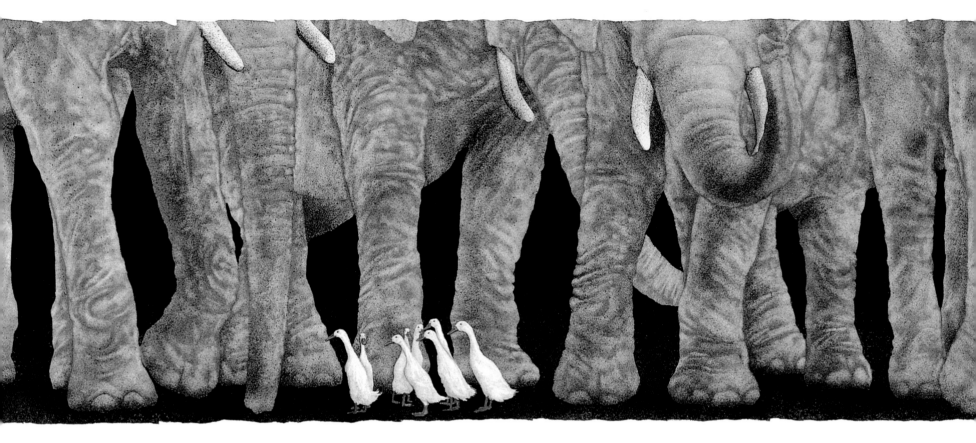

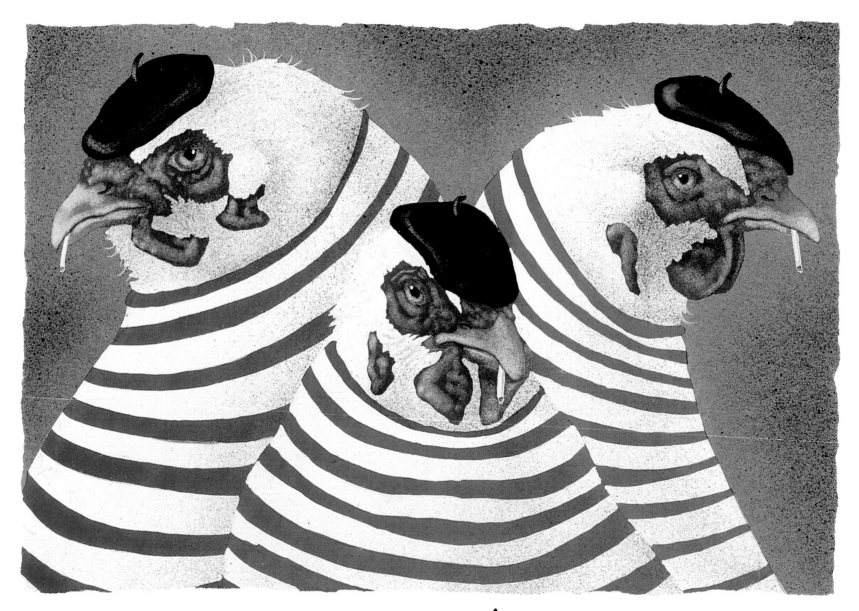

the third day of Christmas...

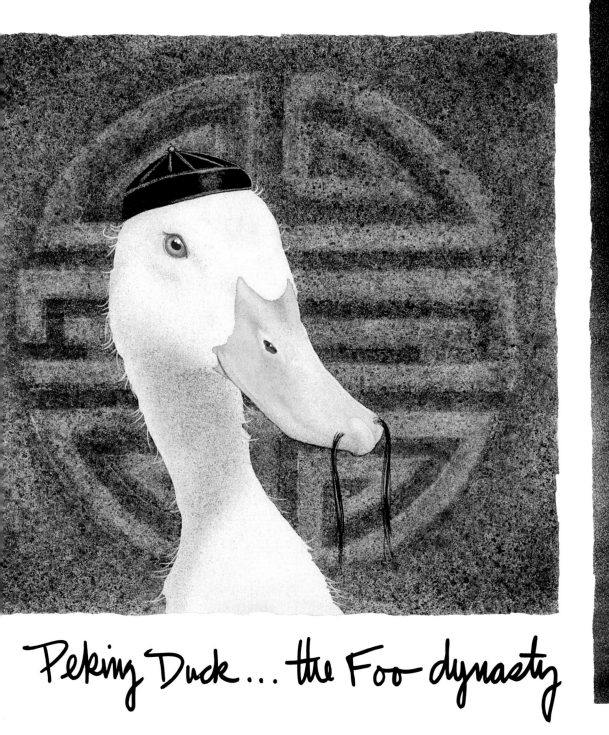

Peking Duck ... the Foo dynasty

uncle ...

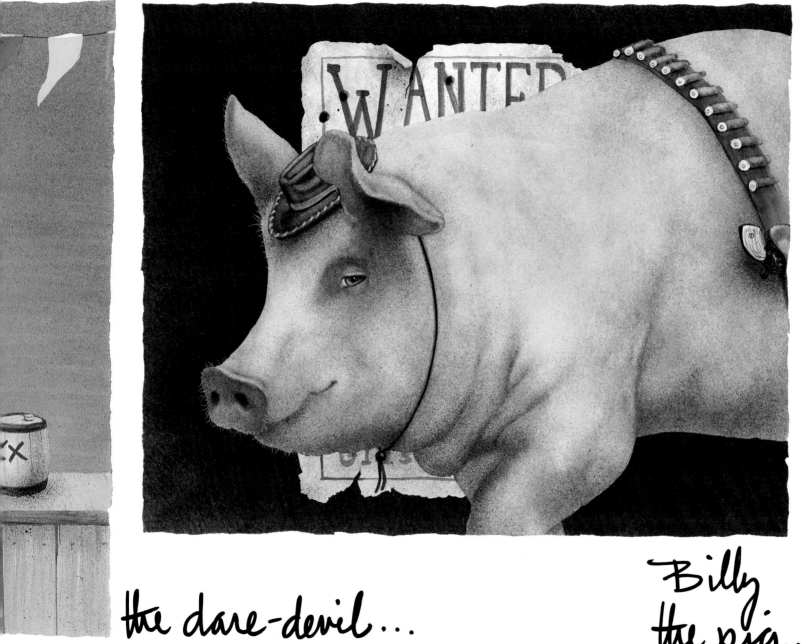

the dare-devil...

Billy
the pig...

the
trick
rider...

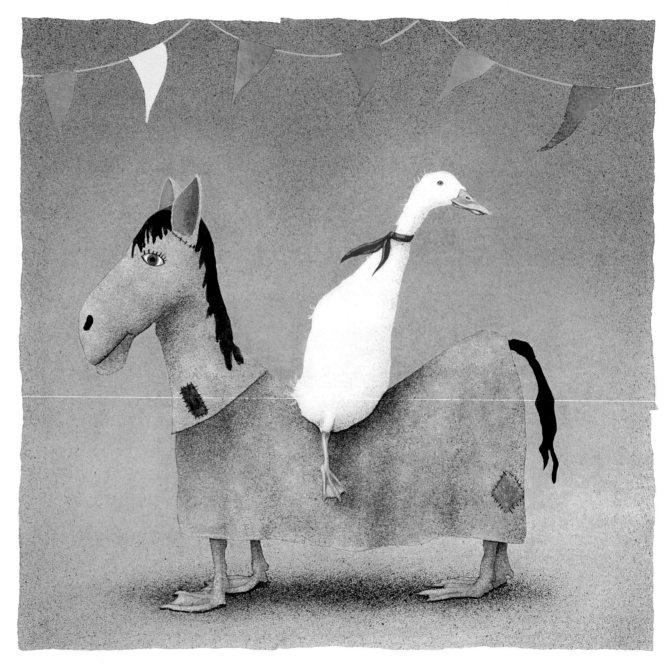

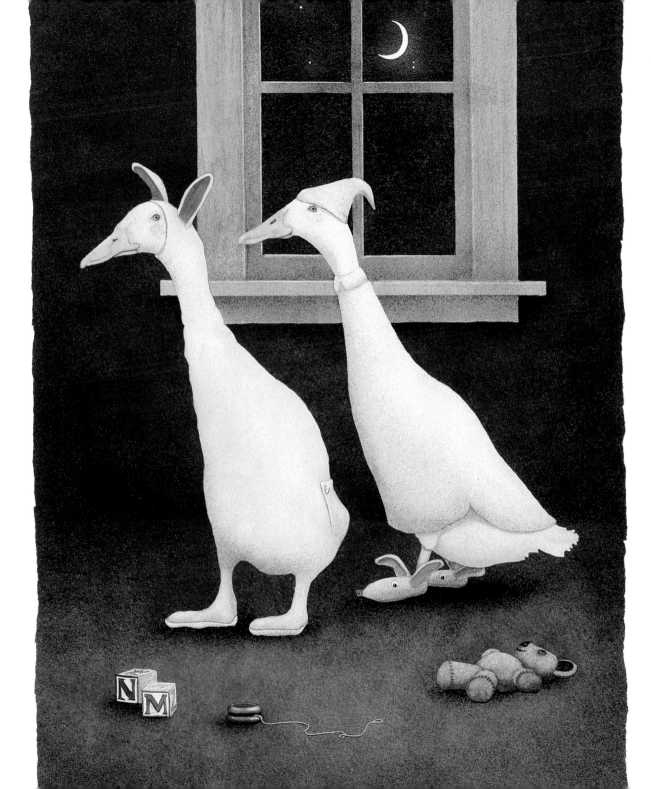

bedtime
buddies...

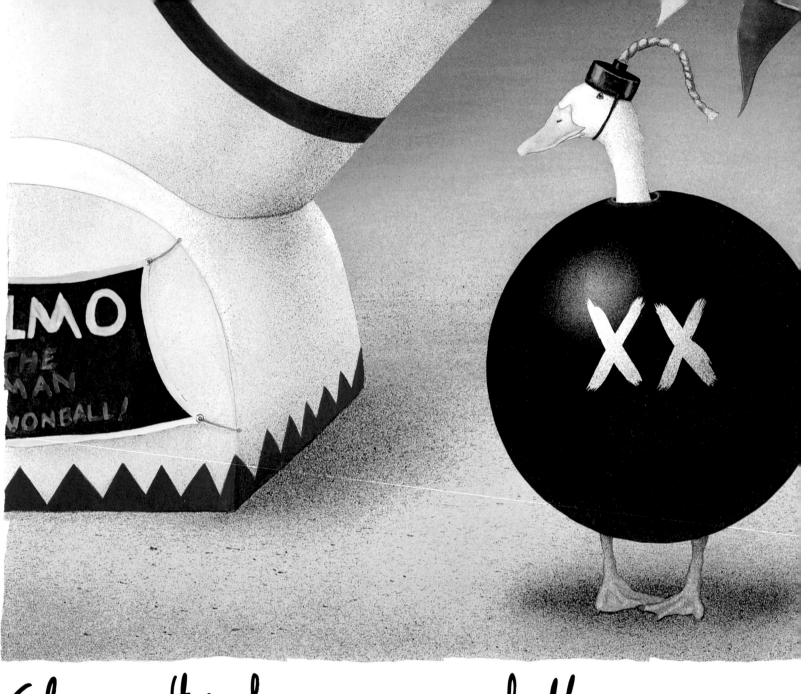

Elmo... the human cannonball

clucks unlimited ...

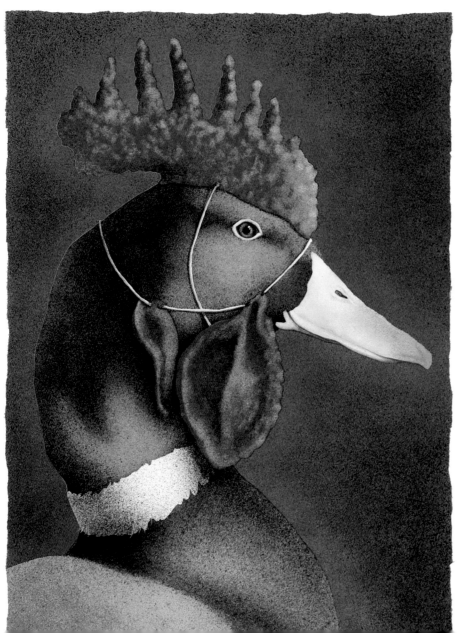

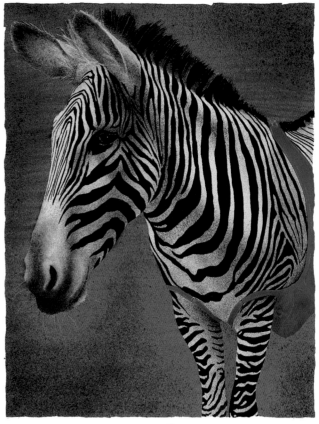

zee-bra ...

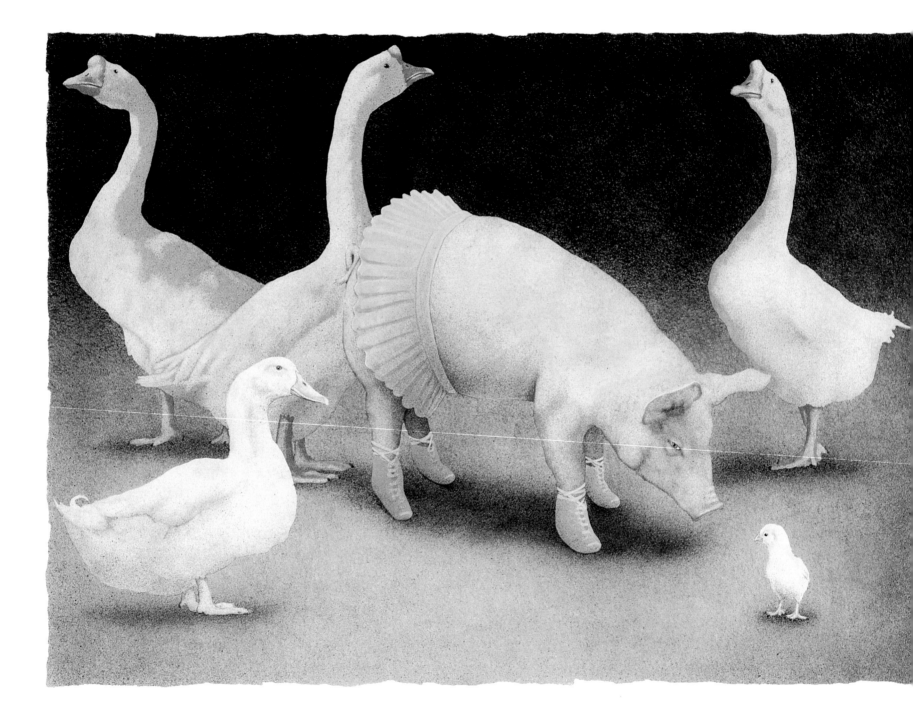

the
prima
donna...

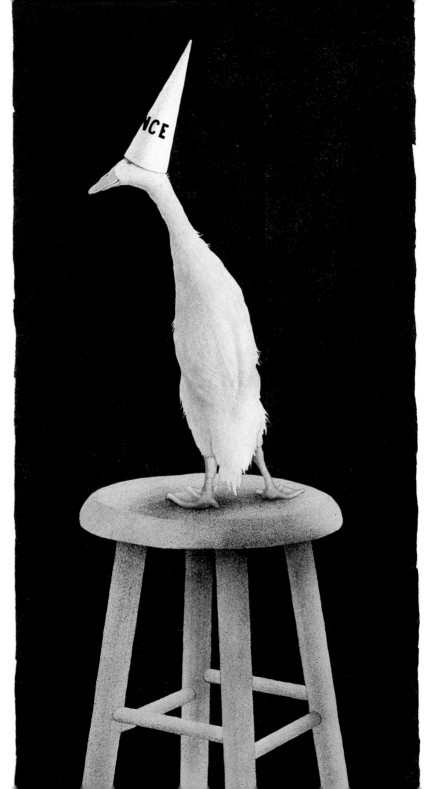

head
of the
Class...

Zippo...
the
fire-eater

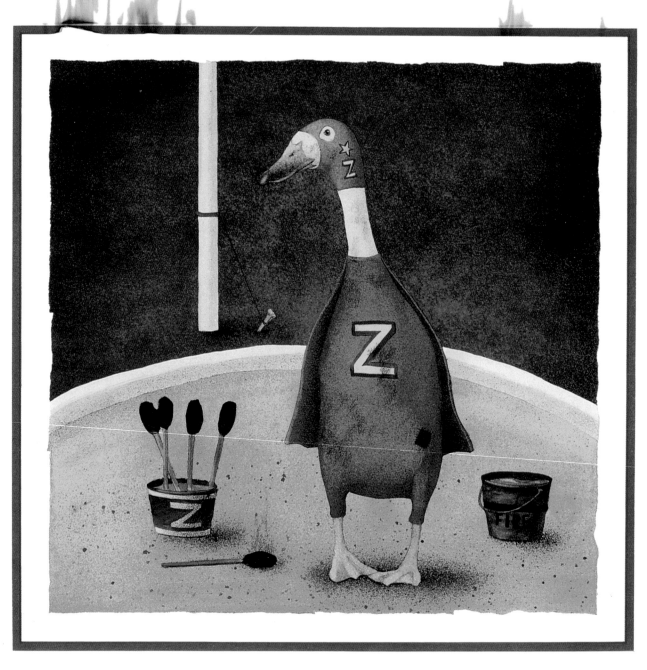

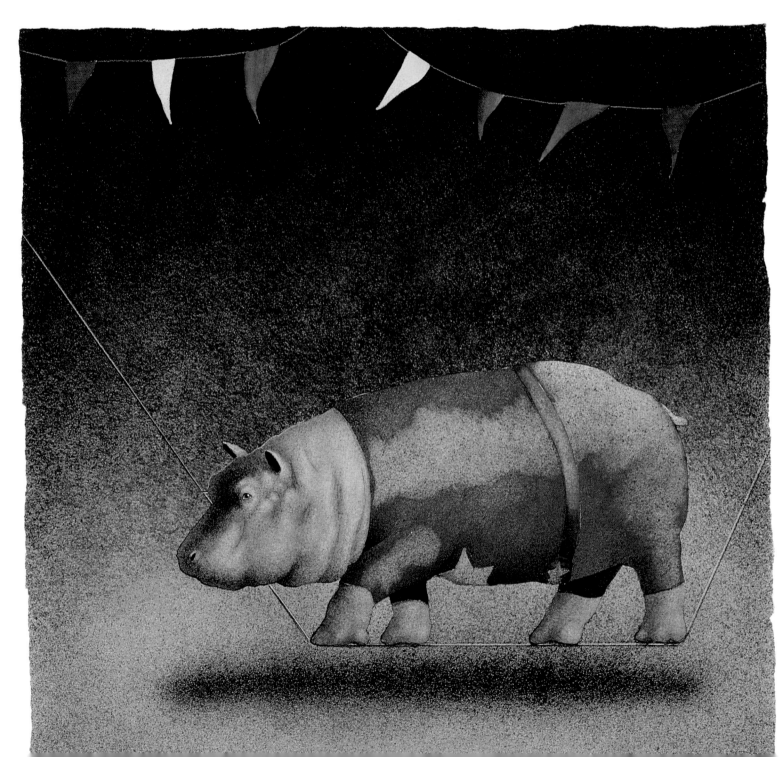

the
high
wire...

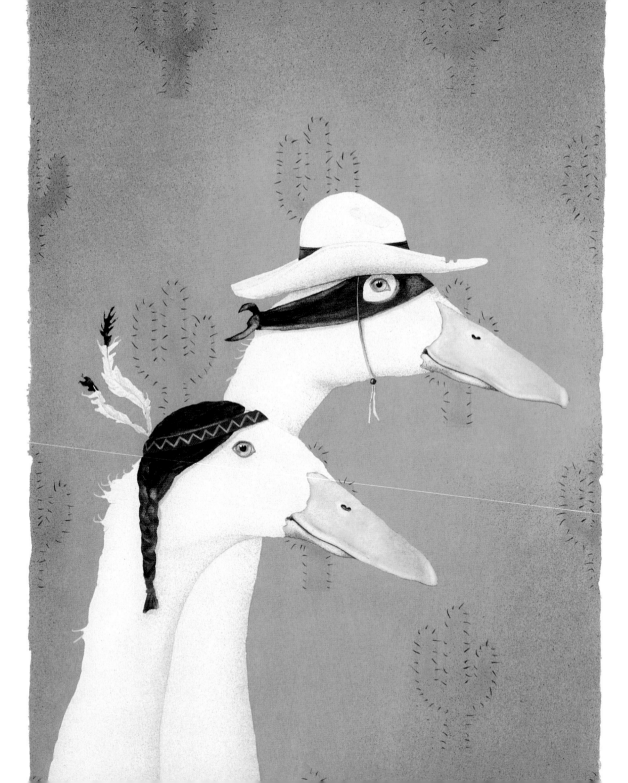

faithful
companions...

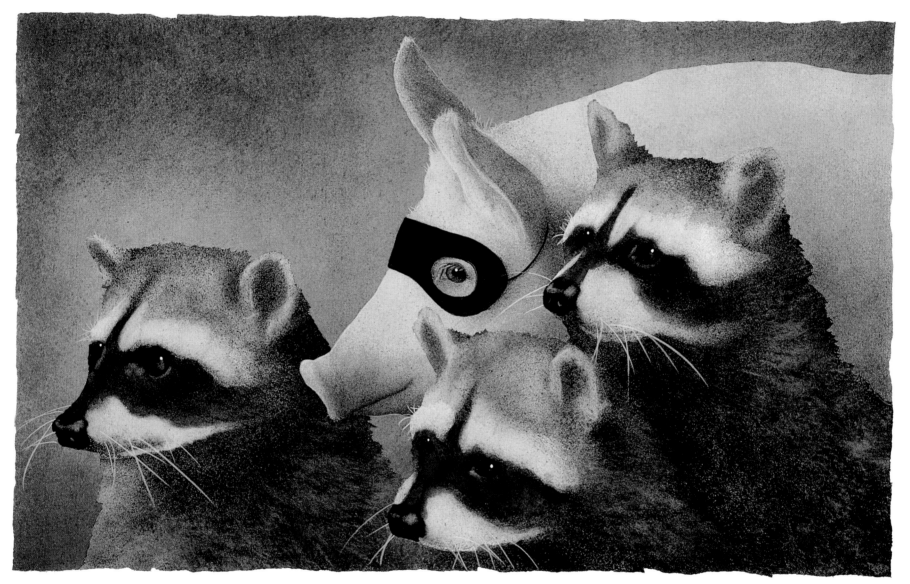

just one of the guys...

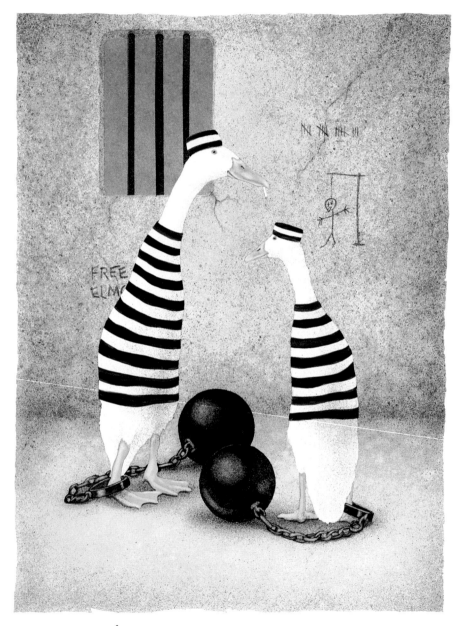

the jailbirds . . .

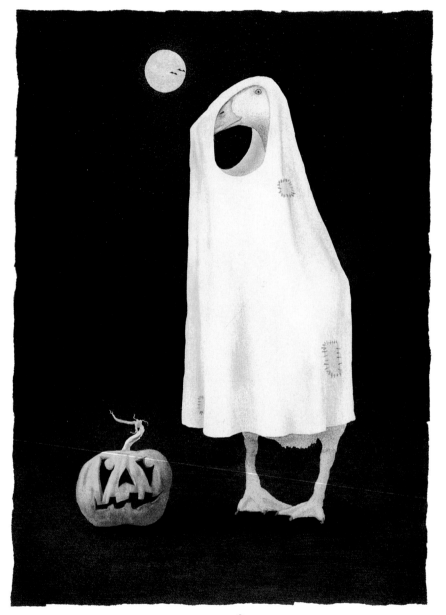

trick or treat . . .

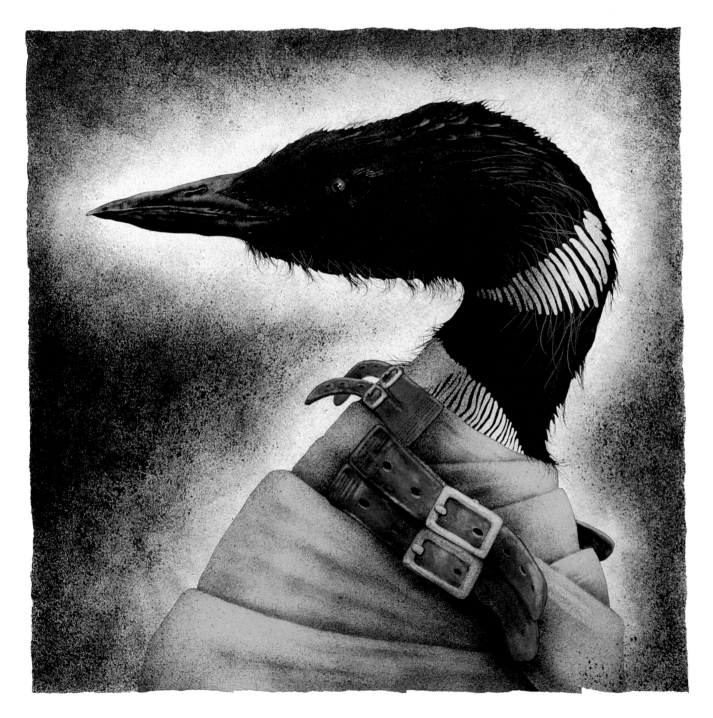

the
loon...

the
harepiece...

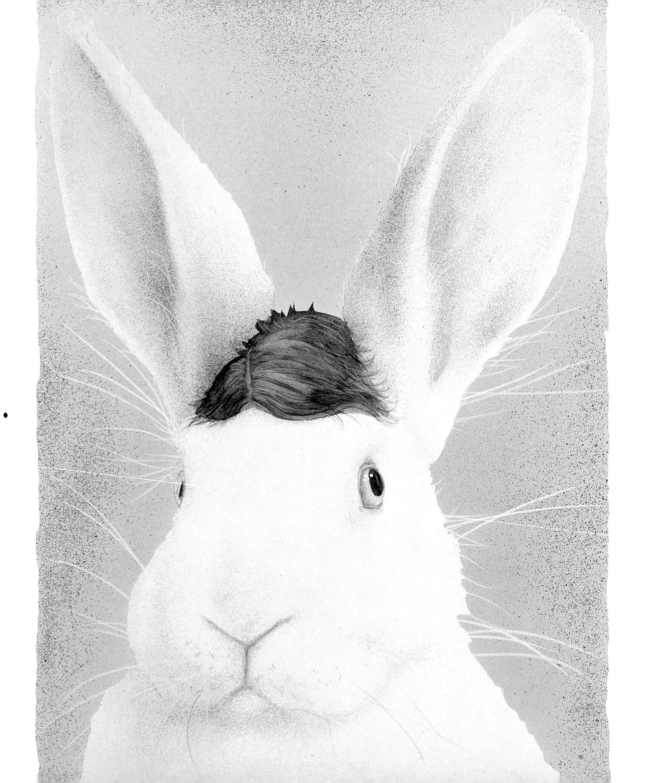

Fridays after five...

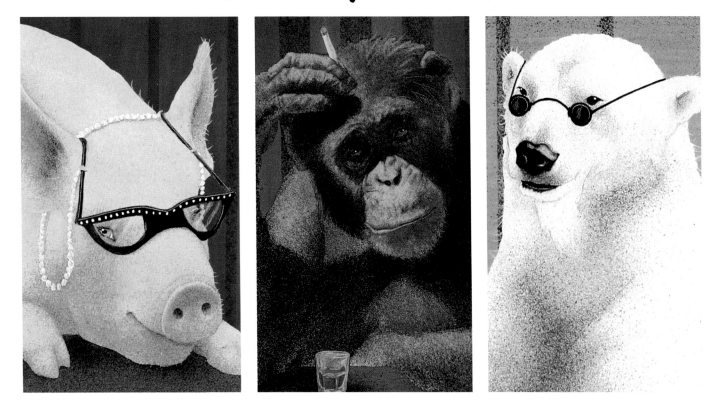

Fridays after five...

It's usually celebrated as the beginning of the weekend—a time of fun and frolic, a time for the pursuit of leisure, a time to let our feathers down. It is also time to ask such burning questions as "What happens when you throw a few monkeys, gorillas, and bears into a pitcher and stir gently?"

Well, it's a jungle out there, even when our time is our own. Shedding the guise of nine-to-five lives leaves even more room to roam for the animal we harbor inside. Perhaps, upon closer examination, the worst will be confirmed: somewhere, somehow, someone thinks you're actually quite silly. The best thing to do is sit back, relax, and laugh.

Don't be surprised if you find Will Bullas looking over your shoulder. From the mating game to the golf game, it will be noted and filed away for a fine-art treatment some day. A trip to the zoo, a few hours in a museum, an idle moment during a particularly pleasant daydream, or a vacation on his wife's family farm will be all it takes for the connection to be made. Something clicks and someone invariably asks, "Is something burning?"

No. Will has just caught us in the act.

Again.

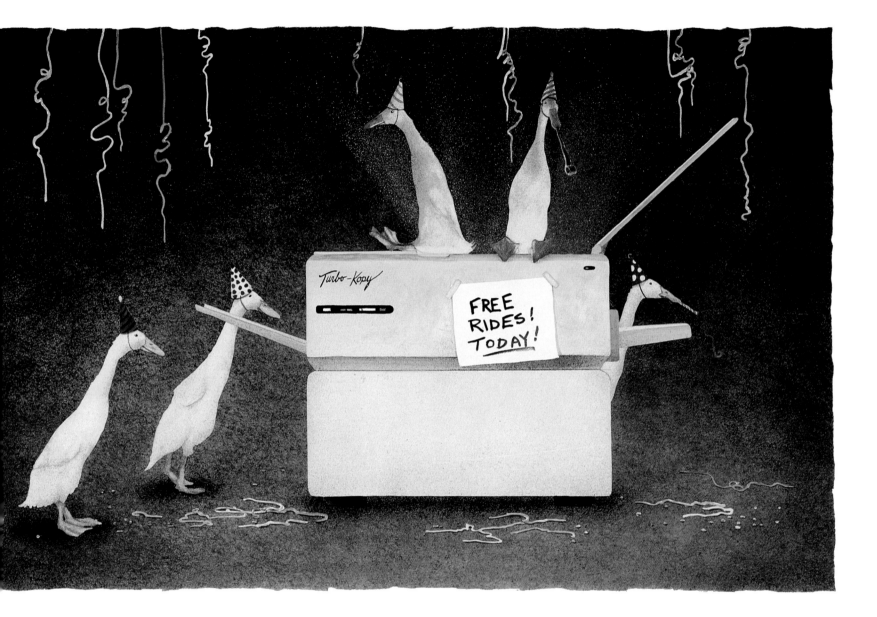

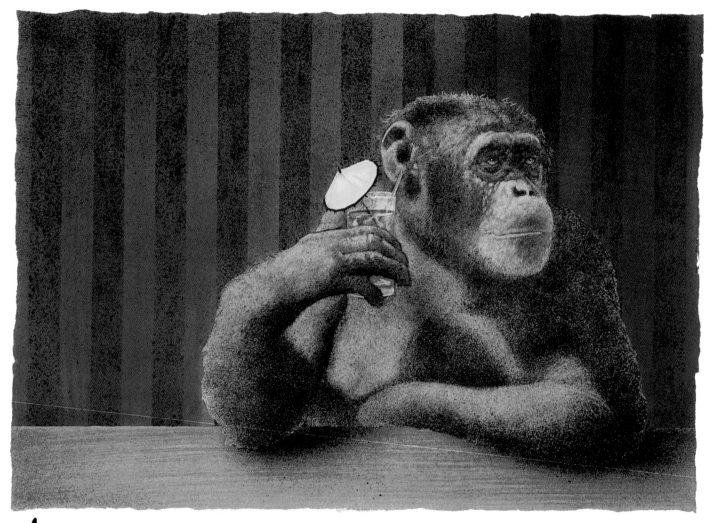

the monkey bars...

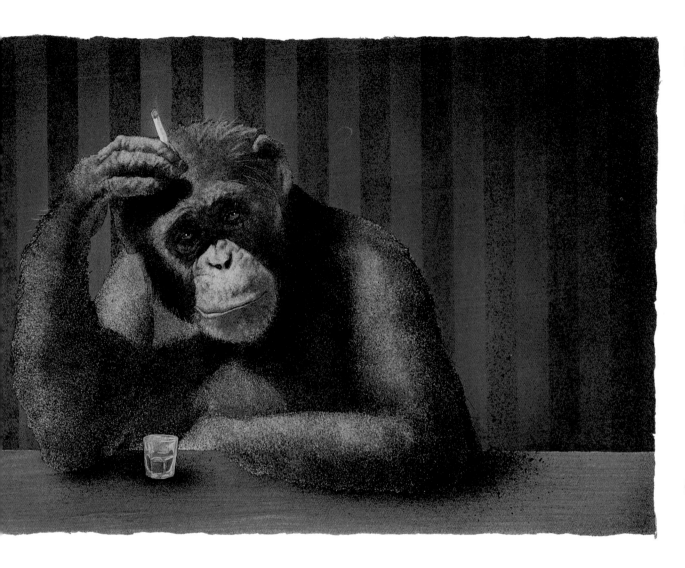

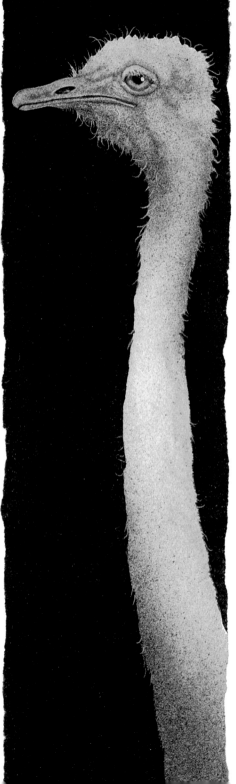

up all night...

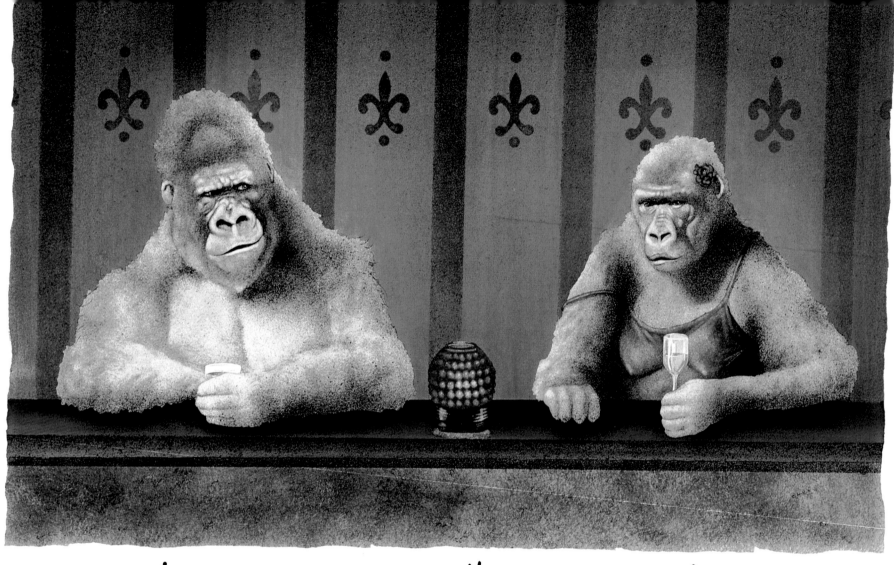

goin' ape down at the monkey bar . . .

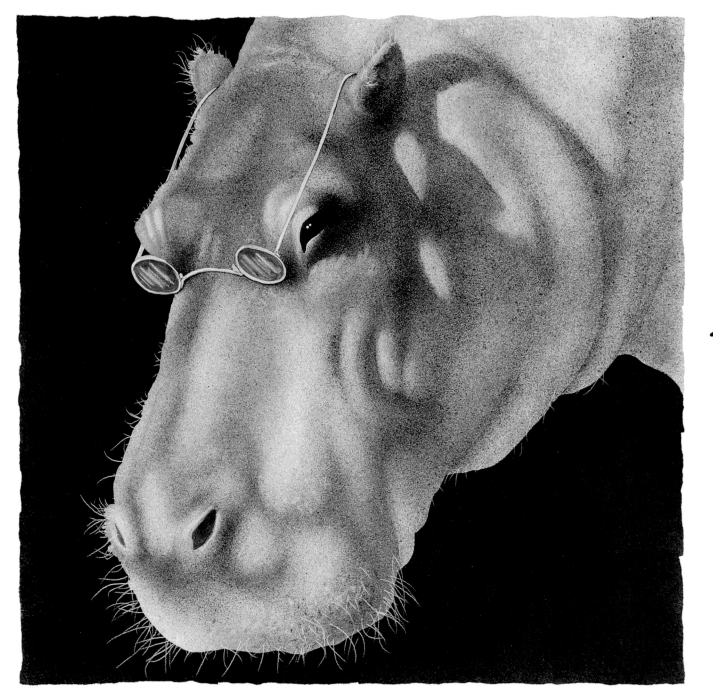

the hippy...

a
black
and
white
affair...

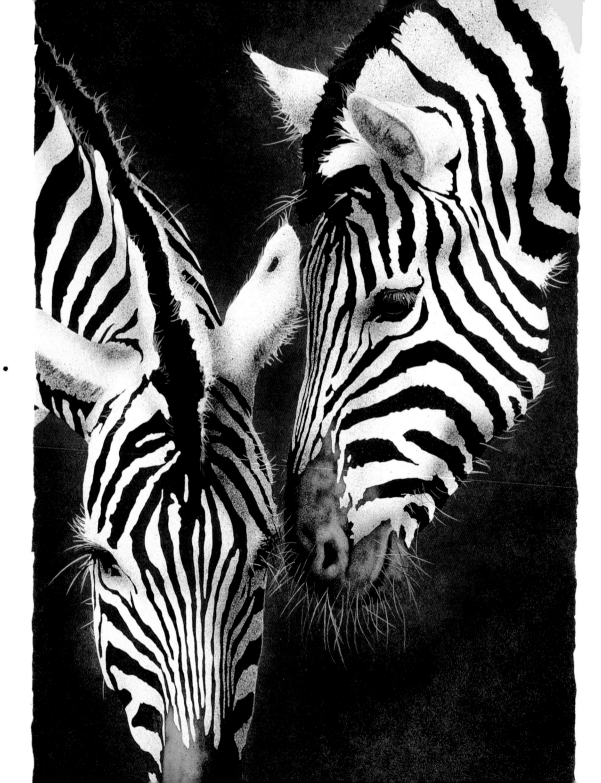
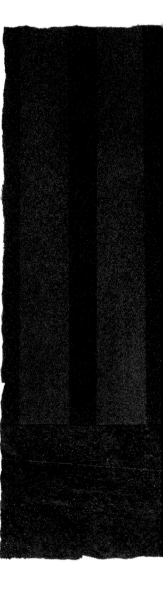

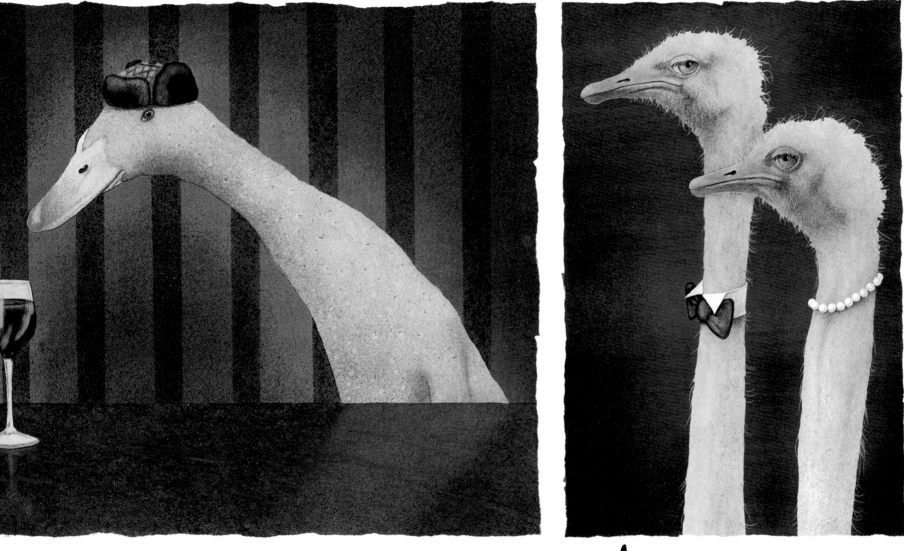

cold duck... high society...

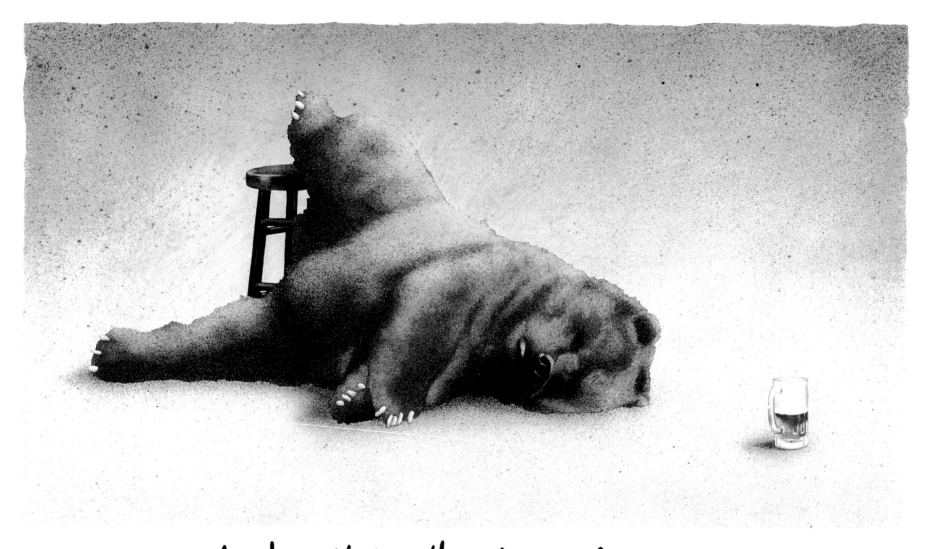

last call for the bear bar....

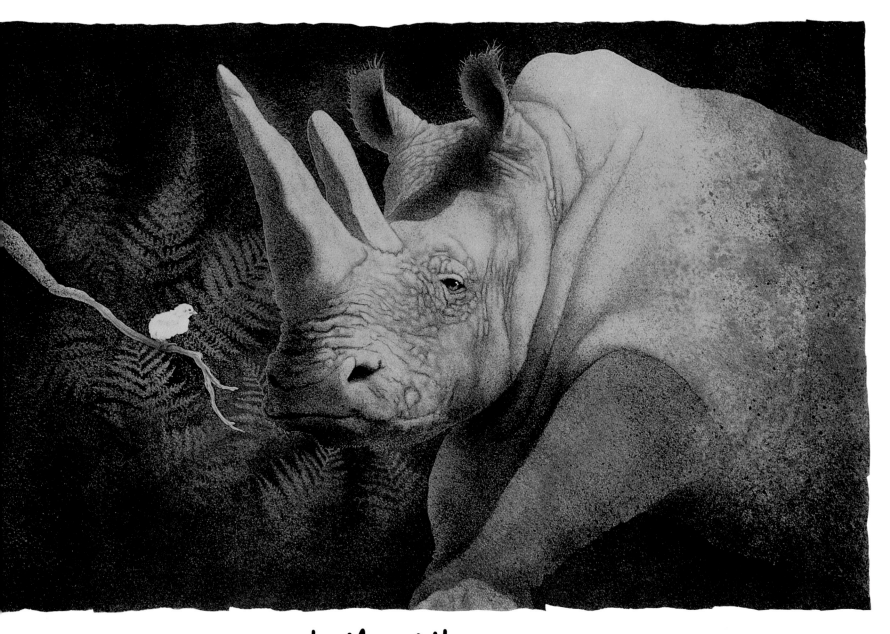

just small talk with some chick …

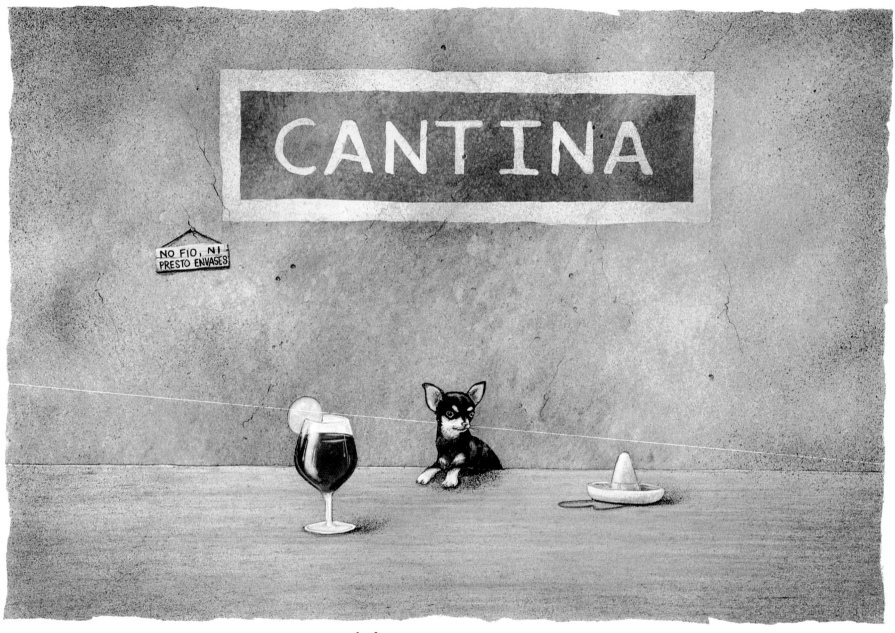

a little Sangria . . .

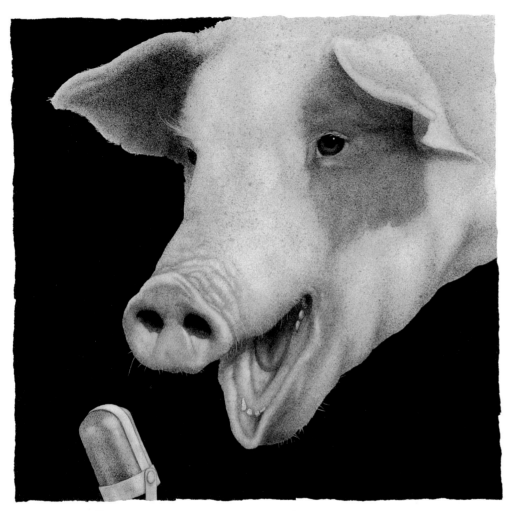

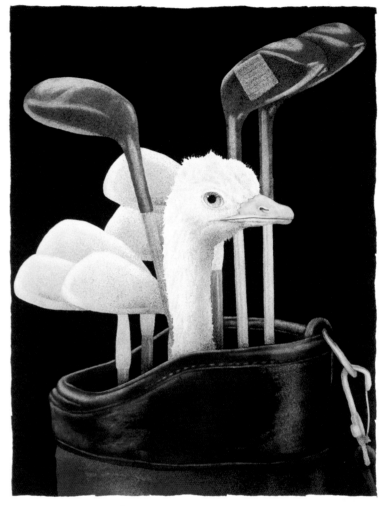

hamateur hour ...

sand trap pro ...

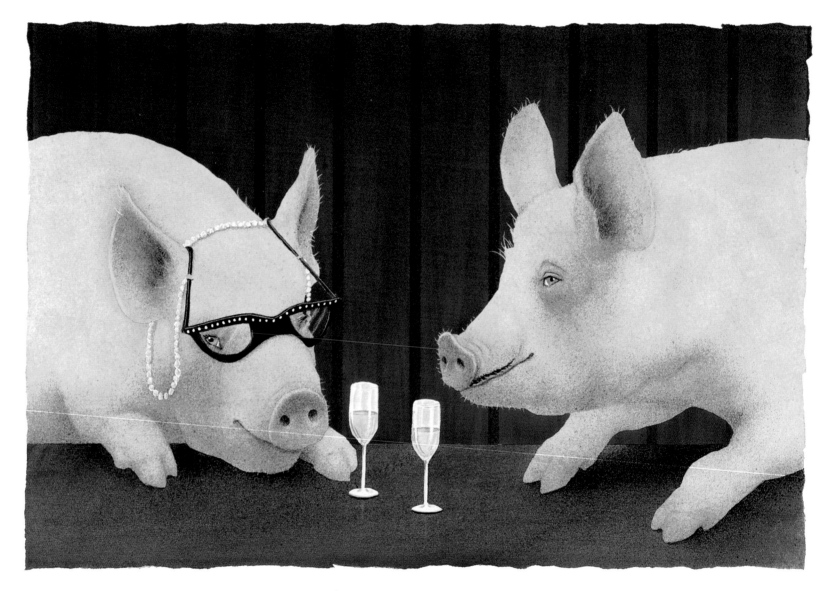

the house swine...

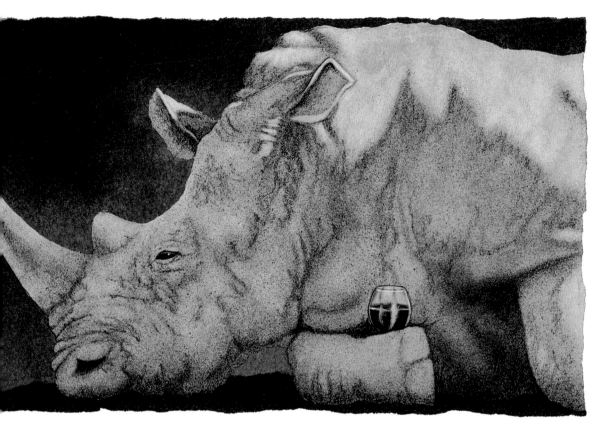

wine-oceros...

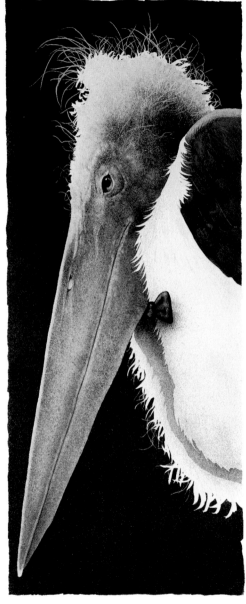

you rang, madam?

punky
derm . . .

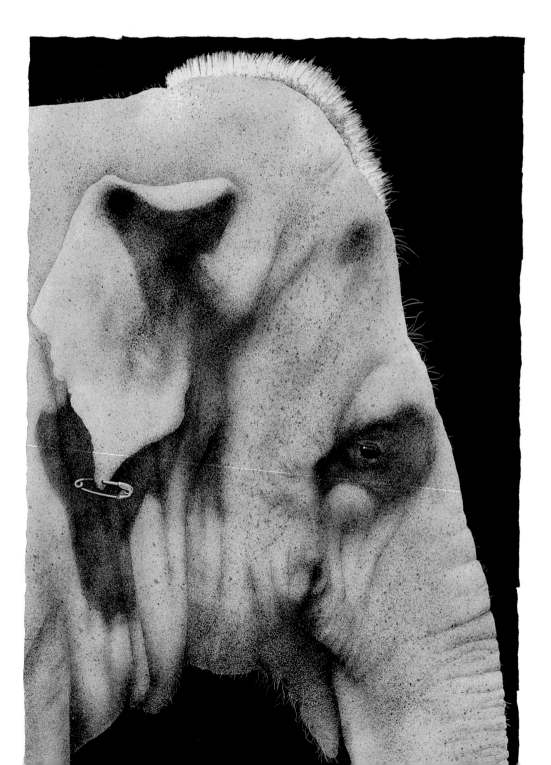

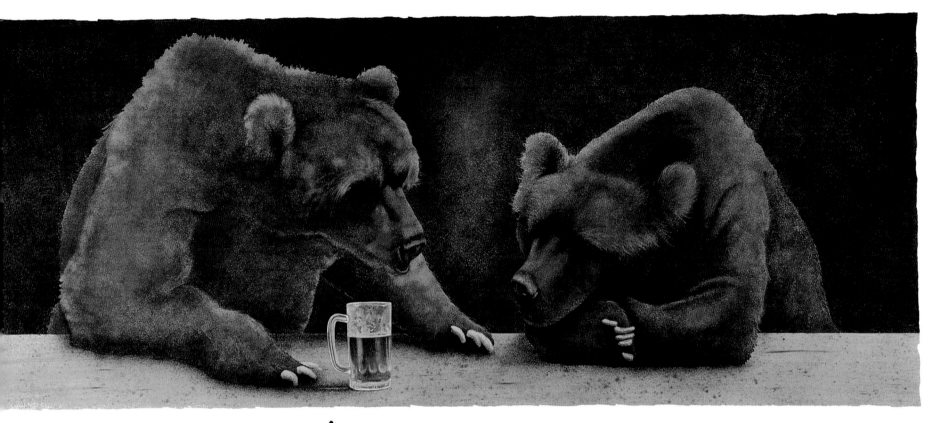

the bear bar...

3-D double creature ...

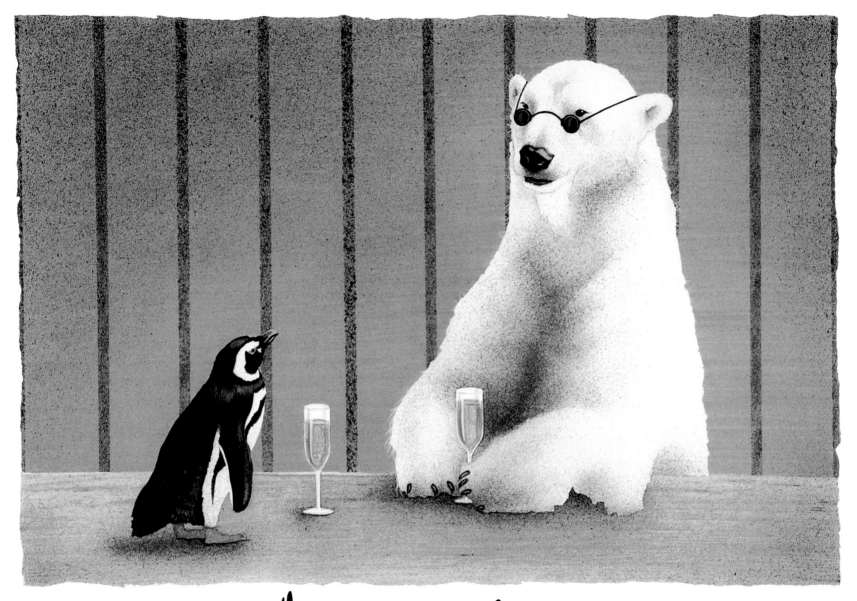

the wine coolers ...

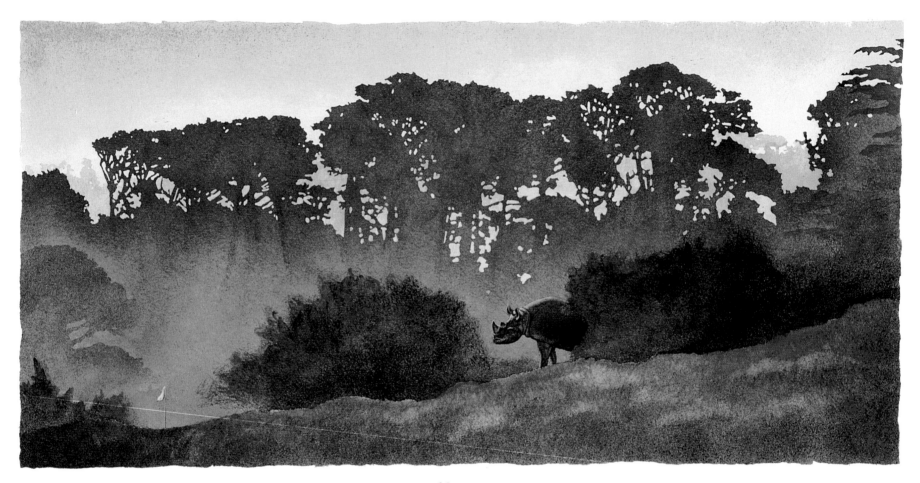

rhino in the rough...

PART III

just a hare to the right...

just a hare to the right...

Who says fine art can't be funny? Critics sneer at the idea. Stuffy collectors frown on it. Pretentious art dealers simply won't have art lovers giggling and guffawing in their hallowed halls. None of this is true at a Will Bullas exhibition. It's music to the artist's ears to hear explosions of laughter from every corner of the gallery.

What's a joke without a punch line? It's a Will Bullas painting without a title. Here are the classic Bullas illustrated one-liners—brilliant watercolors that cannot live without their stingers. Sometimes the image is a puzzle and the title its solution. Sometimes the title is a mystery and the image is its denouement. Either way, for Will, the play's the thing, whether it is a morality play, a play on words, or just a hare to the right.

Bunnies on the brain? No, simply a wordsmithing artist who shares his love of life through his animal instincts—all puns intended. Here there be chickens and pigs and frogs— oh, my—and apes and lions and llamas. No matter which beast you might see, all are indelibly attached to their tag lines. How much is that doggy in the window? The price is a smile.

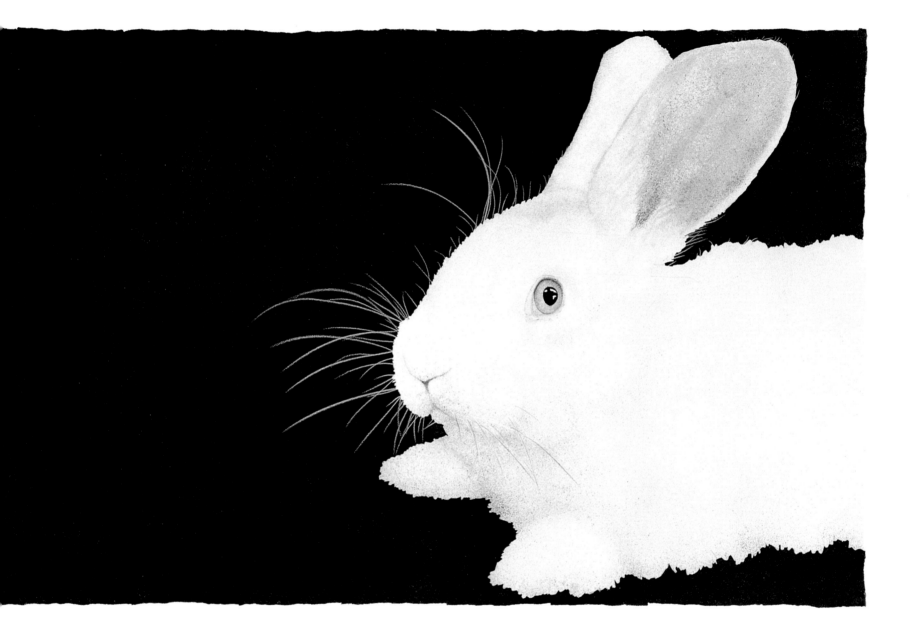

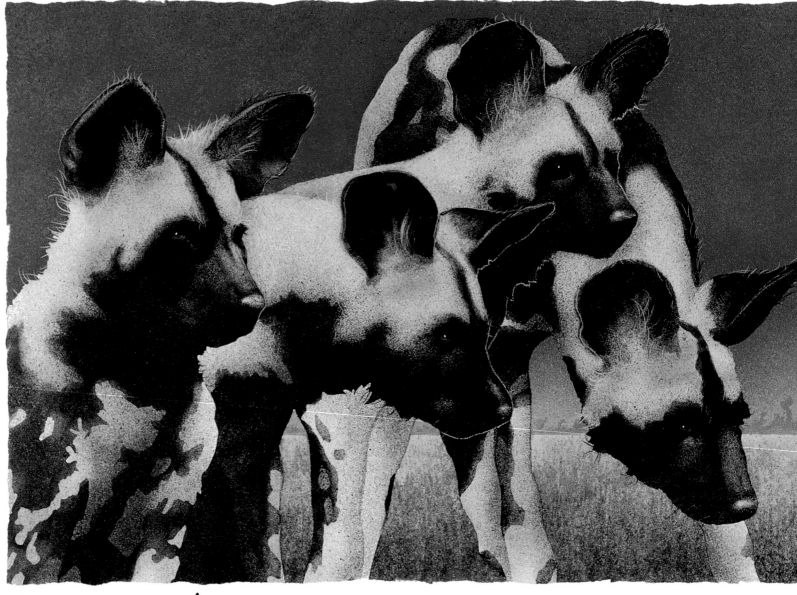

Africa by the pack...

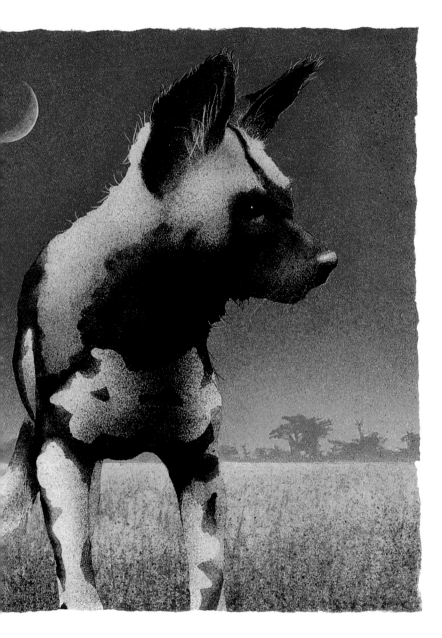

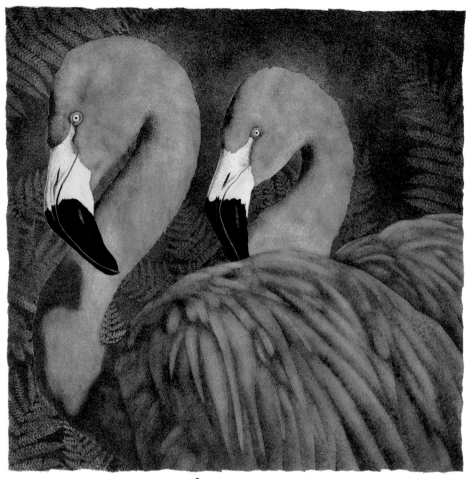

our ladies of
the front lawn...

Mr. Harry Buns...

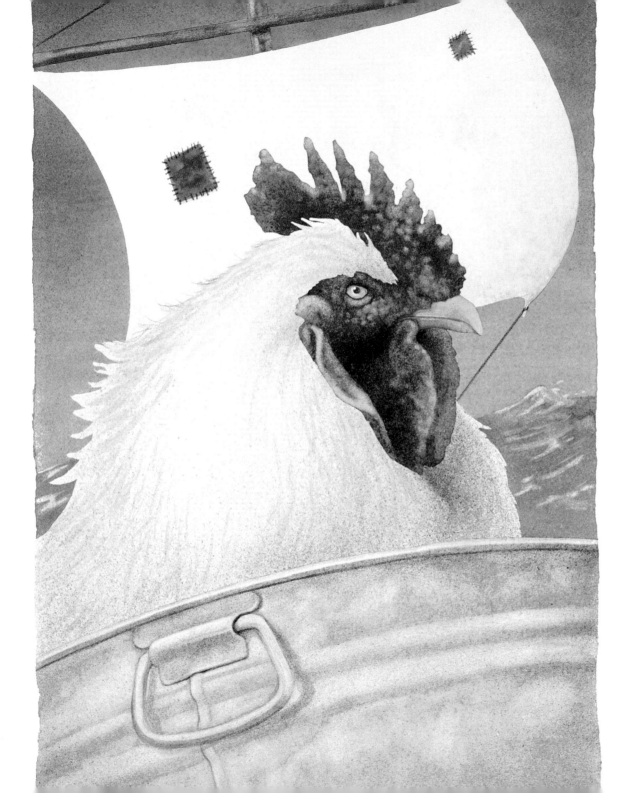

chicken

ship ...

Rather
large and
somewhat
hairy
buns...

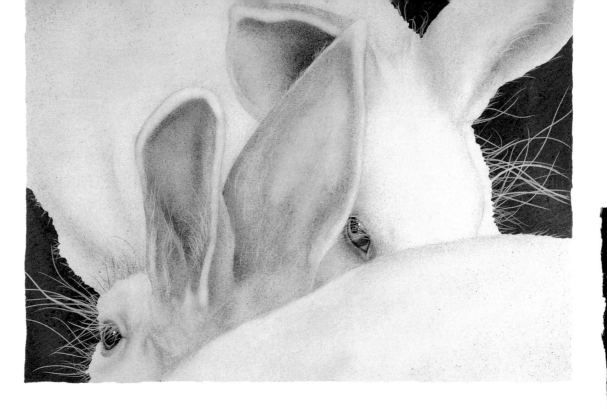

cool
yule...

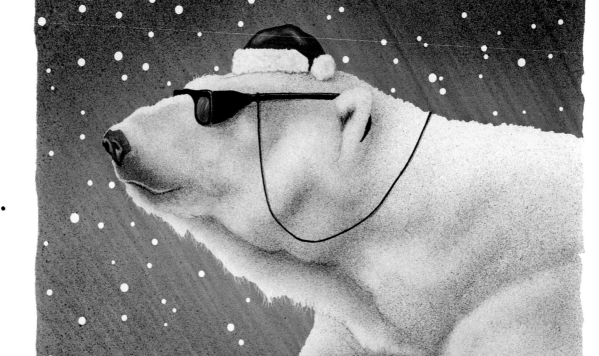

the lonely bullfrog...

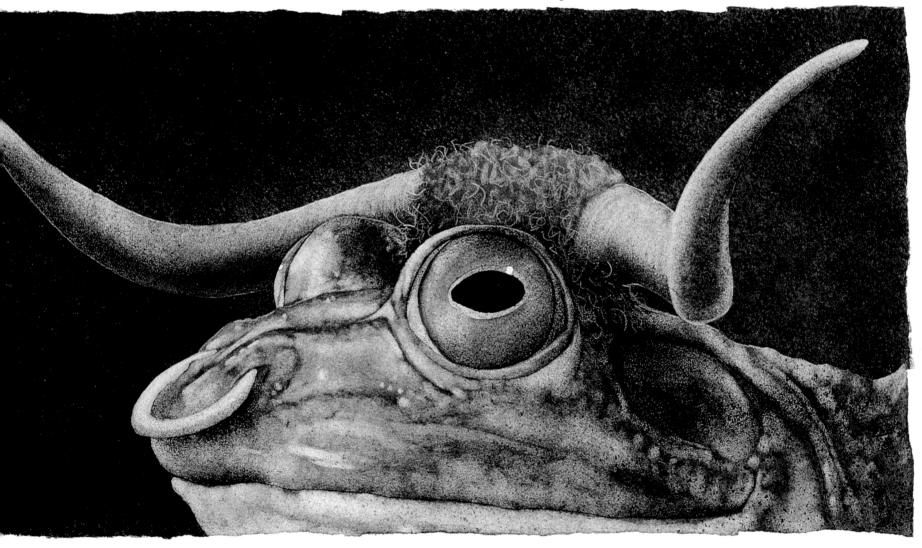

the bell hop . . .

leaper's love...

the pale prince ...

little stinkers ...

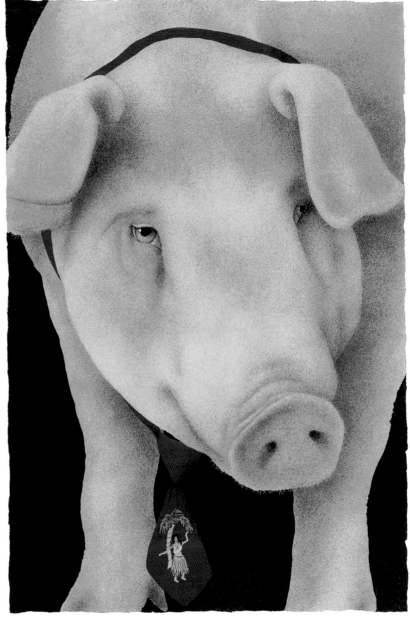

the
pigsty . . .

true confessions…

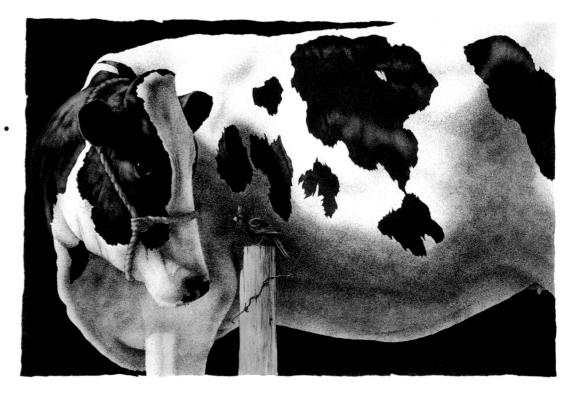

some
set of
buns…

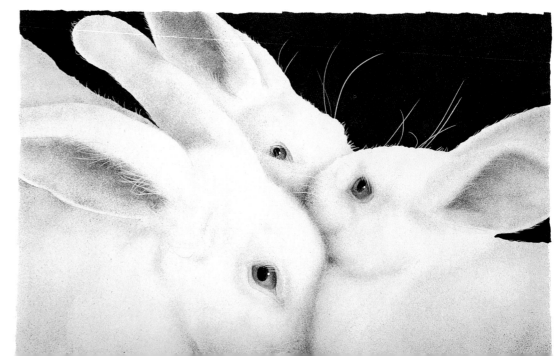

tall, dark, and handsome ...

the theology lesson . . .

a bunch of bull... the dolly llama...

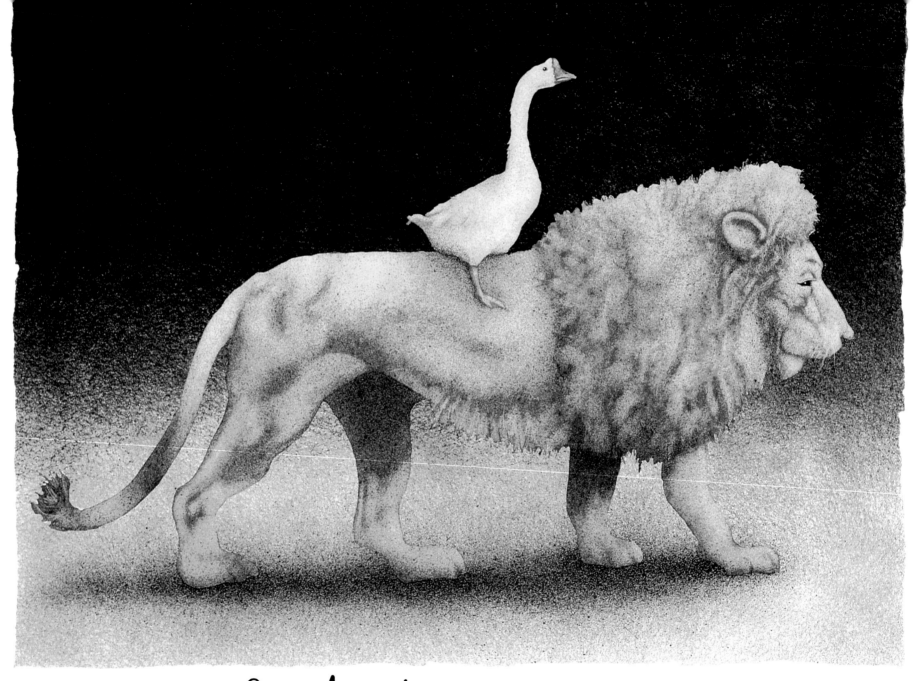

Leo loved a good goose...

PART IV

the human element...

the human element...

The one with the ponytail is Will. He smiles because he doesn't like the alternative. The alternative has presented itself on many occasions but cannot break through Bullas' positive point of view. His childhood was okay, but nothing in it prepared him for the greatest test of his humor and art, which was in Vietnam. His first professional pieces were pencil portraits of fellow soldiers, which were sent to loved ones back home.

Will Bullas was born in Ohio and raised in the Southwest. He has been drawing and painting for as long as he can remember. He enrolled at Arizona State University, where he was majoring in fine arts and minoring in dramatic arts when he was drafted. It was not just as well, but at least the production company he and his college friends had created would no longer be in competition with another aspiring production company run by some guy named Spielberg. "I always wondered what happened to him," muses Will.

The world was a new place when Will returned. There were great movies by that Spielberg guy, great books by John Steinbeck, great music by dead people both grateful and otherwise, and great art, too, by renowned instructor Ray Strong. "He was not only a master of landscape painting," Bullas said, "but a master of color theory. And he could tell a great story, too."

Bullas' work did his training and experience proud, whether it appeared on a restaurant wall, in a shopping mall's parking lot, or at prestigious exhibitions at the New Masters Gallery. Will has awards from the American Watercolor Society, the Adirondacks

Choose your own captions
for the preceding page!
Madam Ruzicka...
Will Bullas
Maya

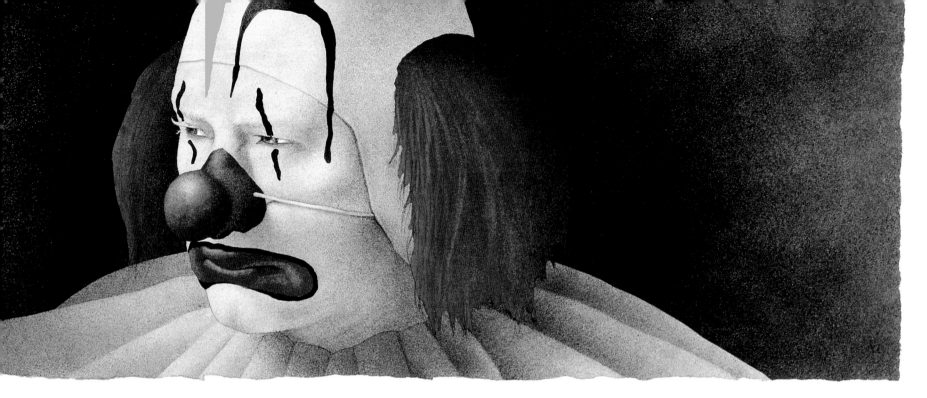

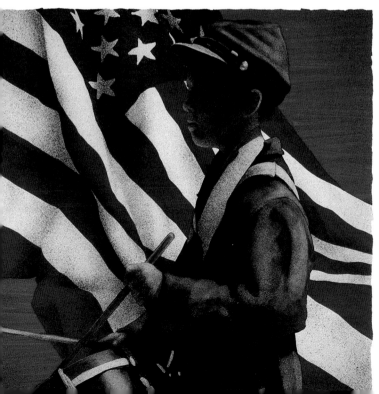

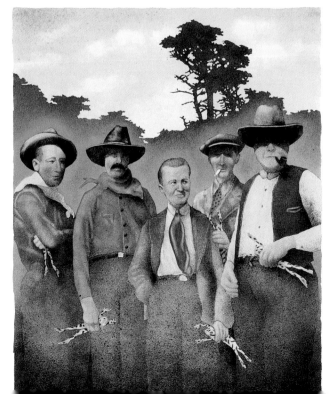

jesters do often prove prophets…
(above)

the freedom drummer…
(bottom left)

Mack and the boys…
(bottom right)

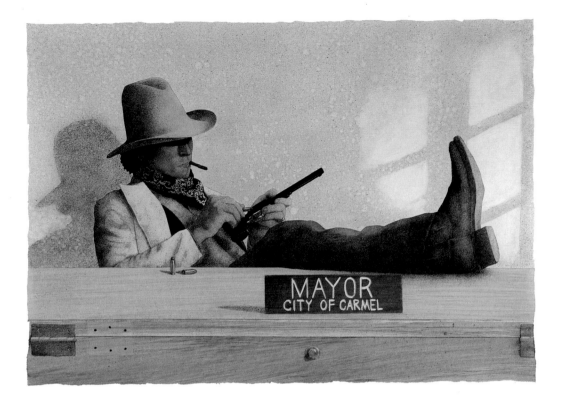

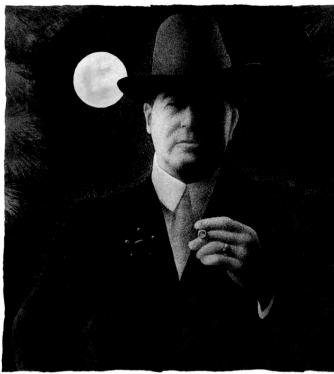

National Exhibition of American Artists, The National Watercolor Society, and the Knickerbocker Artists, but that is not as important to him as a smile or a knowing nod from an appreciative viewer.

The following are considered Bullas' "serious art"—that is, the ones with few jokes to tell. But as Will himself will tell you, they're *all* serious, whether you're rolling around the floor or studying it with a good long "hmmmmmm." Will Bullas' art is for everyone, and it hangs wherever anyone loves it. And why not? Consider the alternative.

if you can't stand the heat…
(left)

moonshine marshall…
(center)

the mad monk…
(right)